This book is dedicated in loving memory to my aunt, Mildred Brill, who inspired in me early in my life her love of nature and the great outdoors, and to Jim McGrath, who is my supportive best friend and life partner. He has helped me make this book possible.

Second Edition 2004

ISBN 978-1-889833-80-4

Cover and interior design by Peter Blaiwas, Vern Associates, Inc.
Printed in South Korea.

Published by Commonwealth Editions
an imprint of Applewood Books, Inc.
Carlisle, Massachusetts 01741
www.commonwealtheditions.com.

The New England Landmarks Series
Cape Cod National Seashore, photographs by Andrew Borsari
Newport, photographs by Alexander Nesbitt
Providence, photographs by Richard Benjamin
Revolutionary Sites of Greater Boston, photographs by Ulrike Welsch
Walden Pond, photographs by Bonnie McGrath

Walden Pond

PHOTOGRAPHS BY BONNIE McGRATH

Reflections by Henry David Thoreau

COMMONWEALTH EDITIONS
Carlisle, Massachusetts

As my thoughts wander to Walden, I think of my earliest memories of the pond. When I was a child of nine or ten, I rode my bike the five or so miles from my home in Acton to take swimming lessons there at Red Cross Beach. At that time the pond was often known as Lake Walden. In later years I walked the shores with my children, with friends, or on solitary excursions. It was on these solo walks or those with my husband Jim, also a photographer, that I began to see Walden as more than "a place to walk"— in fact, it was on one of these walks that Jim proposed to me.

 This book only touches the surface of what one can find at Walden Pond. Making images of Walden and capturing its mystique has become an obsession with me. My favorite times to walk and create photos are dawn and late in the day before sunset. One early morning I arrived just as a storm was fast approaching with rising wind and dark racing clouds, the air alive with tension. As the sun faded, I hurried to place myself in the most opportune position to capture the excitement on film.

 One can arrive before sunrise when the red glow in the east sends a splendid orchestration of color on puffy clouds floating high over the pond—magic! The sights and sounds of the morning may include a chip-munk scurrying through dried leaves just ahead on the path, nervous sand-pipers on the beach chattering to each other and running along the water's

edge, or a hawk rising from the pines swooping in a huge arc over the water. Two black loons play hide-and-seek, diving and surfacing on the west end of the pond. Early morning sun backlights brilliant red sumacs near the water's edge—more magic! Ahead of me a blue heron stands one-legged on the beach, while the eerie mist rises from the surface of the pond. The feeling is ethereal, as if I were in some distant other-world or dream.

If you walk late in the day you may hear an oriole singing its solitary evening song, a hoot owl in the distance, a fish jumping near shore making a huge flop as it falls back into the water, the cawing of crows high in the pines as they settle down for the night. Crickets chirp from the mossy vegetation on the nearby hillside. Darkness descends, leaving the sun glowing on the tops of pine trees on the south side.

I was inspired to publish this book because I wanted to share my personal vision of Walden Pond joined with the timeless observations of Henry David Thoreau—not only for those who have already been here, but especially for those who have never visited. My hope is that they may experience the peace and tranquility I find here, away from the everyday hustle and bustle of this crazy world we live in.

—Bonnie McGrath, November 2000

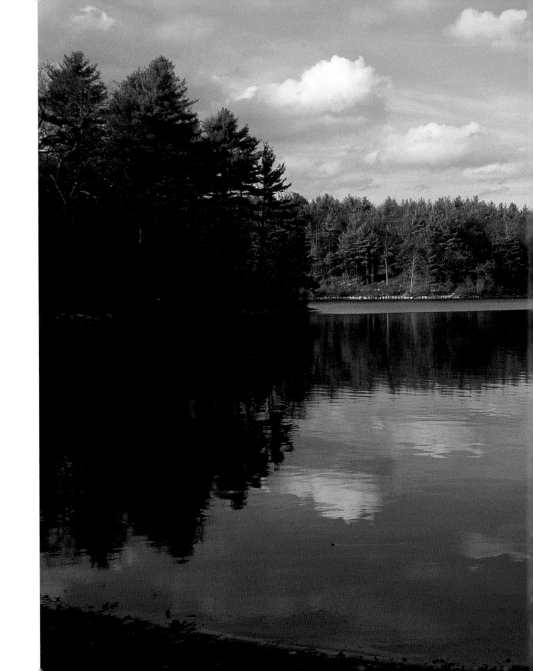

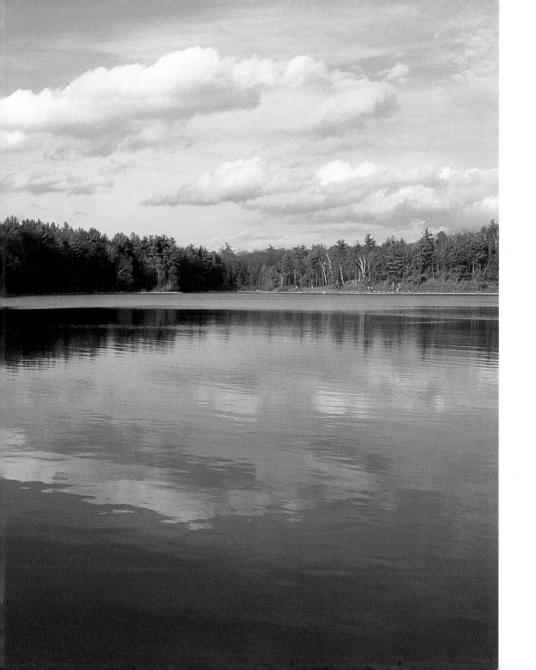

NEAR THE END OF MARCH 1845 I BORROWED AN AXE AND went down to the woods by Walden Pond, nearest to where I intended to build my house, and began to cut down some tall arrowy white pines, still in their youth, for timber.

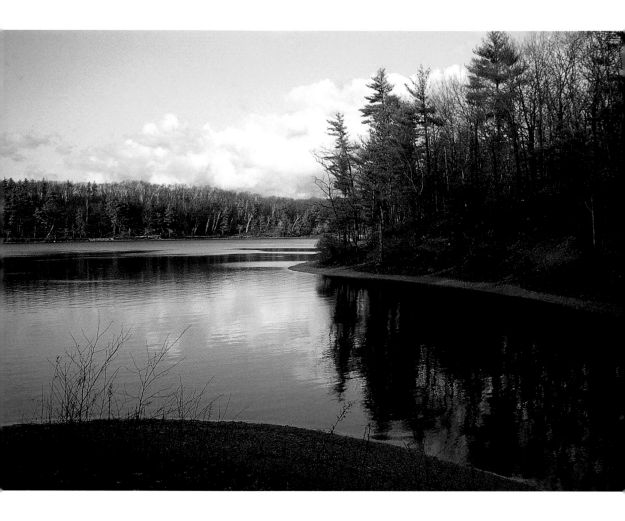

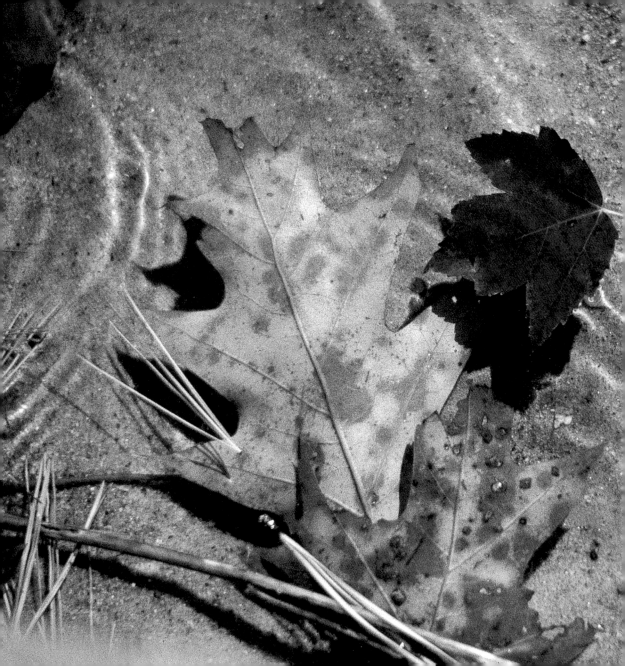

I WENT TO THE WOODS
because I wished to live
deliberately, to front
only the essential facts of
life, and see if I could not
learn what it had to
teach, and not, when I
came to die, discover
that I had not lived.

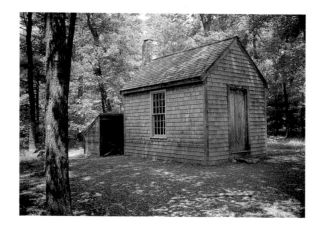

MY HOUSE WAS ON THE SIDE OF A HILL, IMMEDIATELY ON THE EDGE of the larger wood, in the midst of a young forest of pitch pines and hickories, and half a dozen rods from the pond, to which a narrow foot-path led down the hill. In my front yard grew the strawberry, black-berry, and life-ever-lasting, johnswort and goldenrod, shrub oaks and sand cherry, blueberry and groundnut.

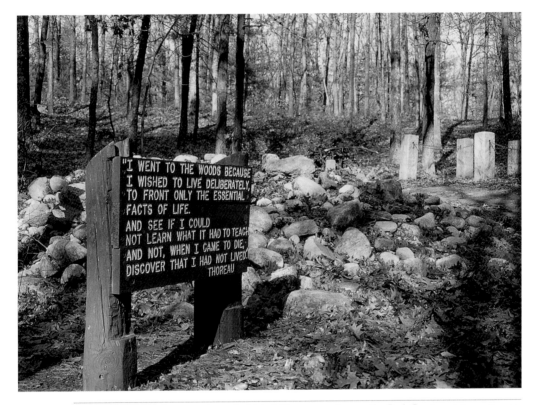

Site of Thoreau's cabin, a replica of which (*left*) now stands near the Park Service visitor entrance.

MY FURNITURE, PART OF WHICH I MADE MYSELF, AND THE REST cost me nothing of which I have not rendered an account, consisted of a bed, a table, a desk, three chairs, a looking-glass three inches in diameter, a pair of tongs and andirons, a kettle, a skillet, and a frying-pan, a dipper, a wash-bowl, two knives and forks, three plates, one cup, one spoon, a jug for oil, a jug for molasses, and a japanned lamp. . . . A lady once offered me a mat, but as I had no room to spare within the house, nor time to spare within or without to shake it, I declined it, preferring to wipe my feet on the sod before my door. It is best to avoid the beginnings of evil.

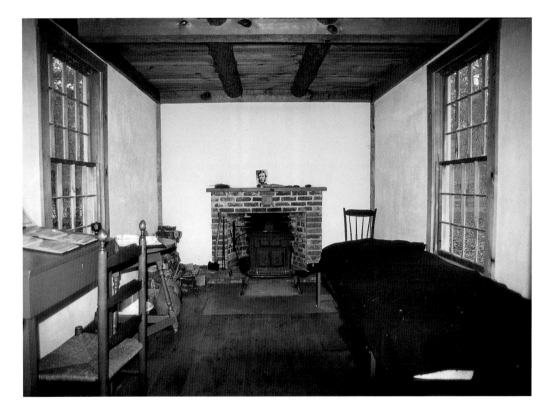

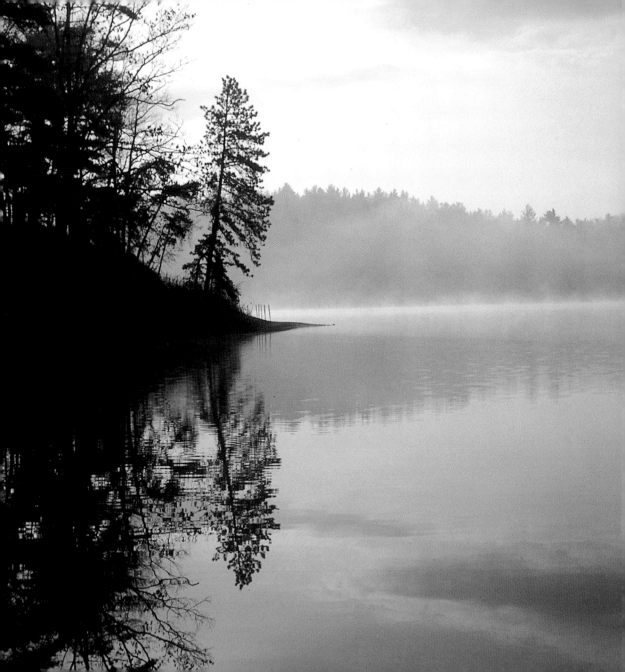

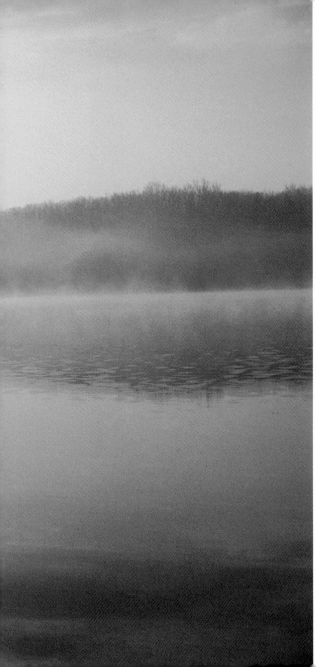

AS THE LIGHT INCREASED, I discovered around me an ocean of mist.

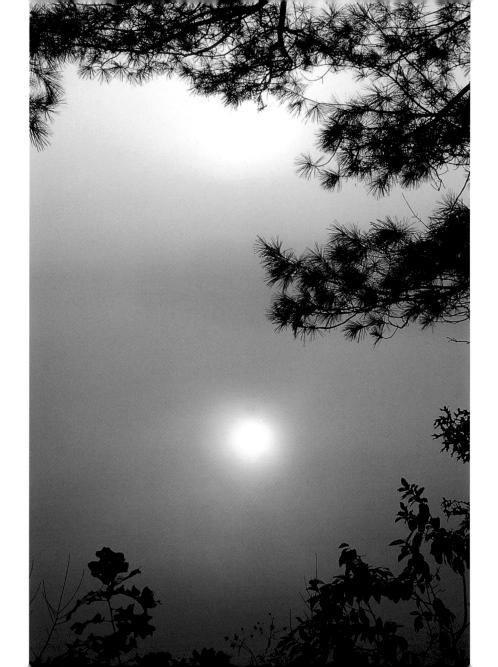

FOR THE MOST PART IT IS AS SOLITARY WHERE I LIVE
as on the prairies. It is as much Asia or Africa as New
England. I have, as it were, my own sun, and moon, and
stars, and a little world all to myself.

The sun is alone, except in thick weather, when there
sometimes appear to be two, but one is a mock sun.

FOR THE FIRST WEEK, WHENEVER I LOOKED OUT ON THE POND
it impressed me like a tarn high up on the side of a mountain, its
bottom far above the surface of other lakes, and, as the sun arose,
I saw it throwing off its nightly clothing of mist, and here and
there, by degrees, its soft ripples or its smooth reflecting surface
was revealed, while the mists, like ghosts, were stealthily with-
drawing in every direction into the woods, as at the breaking up of
some nocturnal conventicle. The very dew seemed to hang upon
the trees later into the day than usual, as on the sides of mountains.

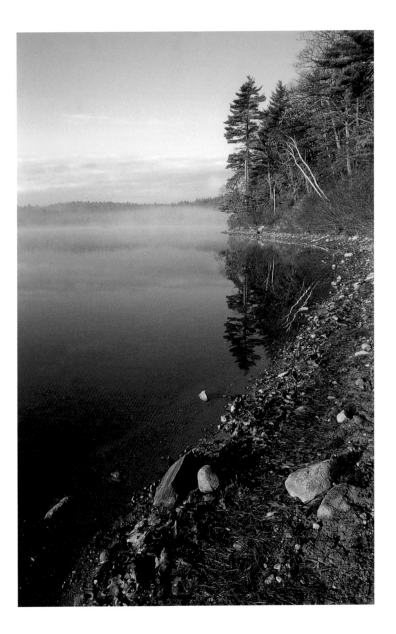

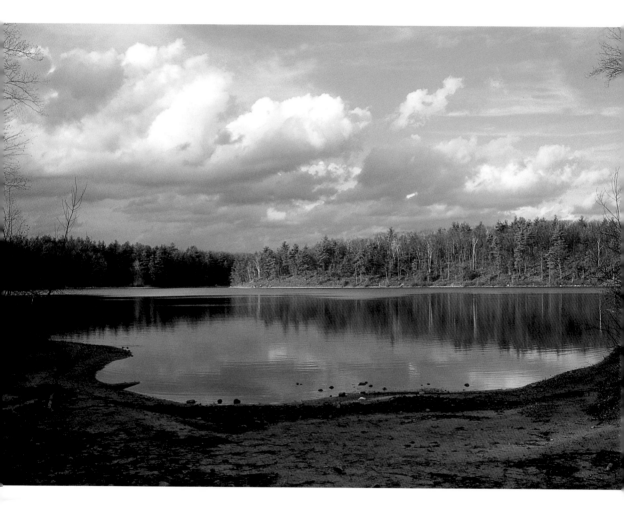

MY TOWNSMEN HAVE ALL HEARD THE TRADITION—
the oldest people tell me that they heard it in their
youth—that anciently the Indians were holding a
pow-wow upon a hill there, which rose as high into
the heaven as the pond now sinks deep into the
earth, and they used much profanity, as the story
goes, though this vice is one of which the Indians
were never guilty, and while they were thus engaged
the hill shook and suddenly sank, and only one old
squaw, named Walden, escaped, and from her the
pond was named.

THE SCENERY OF WALDEN IS ON A HUMBLE SCALE, and, though very beautiful, does not approach to grandeur, nor can it much concern one who has not long frequented it or lived by its shore; yet this pond is so remarkable for its depth and purity as to merit a particular description. It is a clear and deep green well, half a mile long and a mile and three-quarters in circumference, and contains about sixty-one and a half acres; a perennial spring in the midst of pine and oak woods, without any visible inlet or outlet except by the clouds and evaporation.

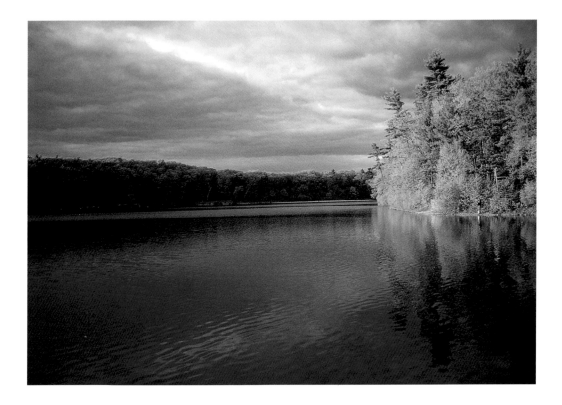

WALDEN IS BLUE
at one time and
green at another,
even from the
same point of
view. Lying
between the
earth and the
heavens, it par-
takes of the
color of both.

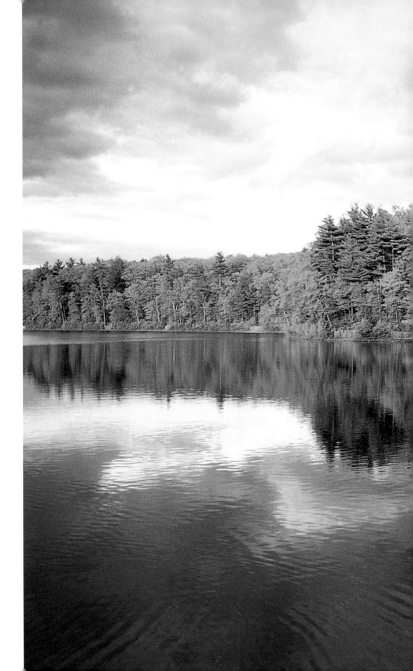

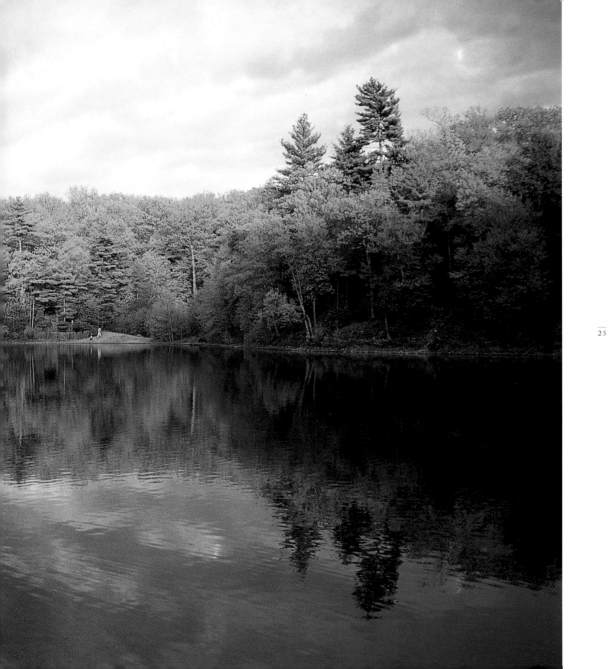

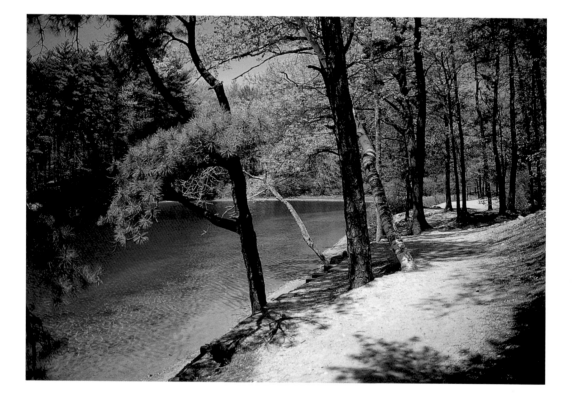

THE SHORE IS IRREGULAR ENOUGH NOT TO BE MONOTONOUS.
I have in my mind's eye the western, indented with deep bays,
the bolder northern, and the beautifully scalloped southern
shore, where successive capes overlap each other and suggest
unexplored coves between.

THE SHORE IS COMPOSED OF A BELT OF SMOOTH rounded white stones like paving-stones, excepting one or two short sand beaches, and is so steep that in many places a single leap will carry you into water over your head; and were it not for its remarkable transparency, that would be the last to be seen of its bottom till it rose on the opposite side. Some think it is bottomless.

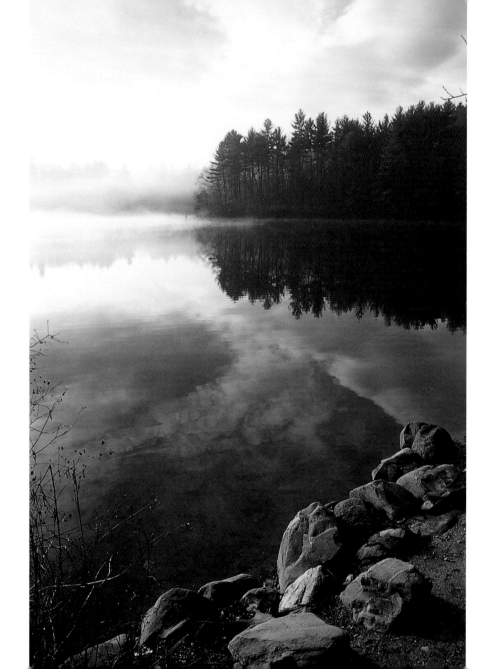

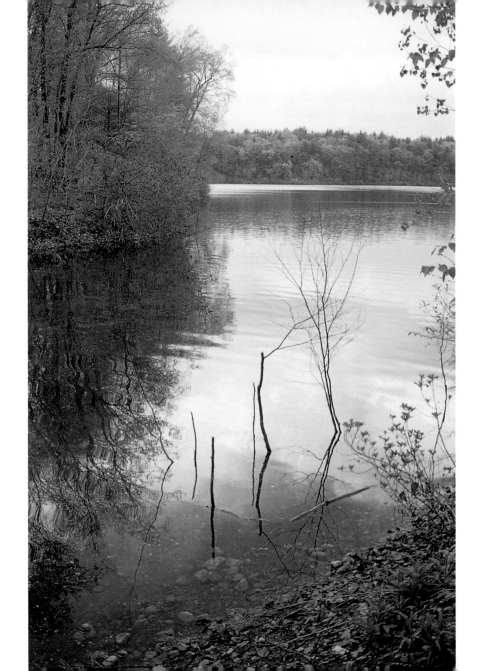

THE PHENOMENA OF THE YEAR TAKE PLACE EVERY DAY in a pond on a small scale. Every morning, generally speaking, the shallow water is being warmed more rapidly than the deep, though it may not be made so warm after all, and every evening it is being cooled more rapidly until the morning. The day is an epitome of the year. The night is the winter, the morning and evening are the spring and fall, and the noon is the summer.

I HEARD THE LARK AND PEWEE AND OTHER BIRDS ALREADY COME to commence another year with us. They were pleasant spring days, in which the winter of man's discontent was thawing as well as the earth, and the life that had lain torpid began to stretch itself.

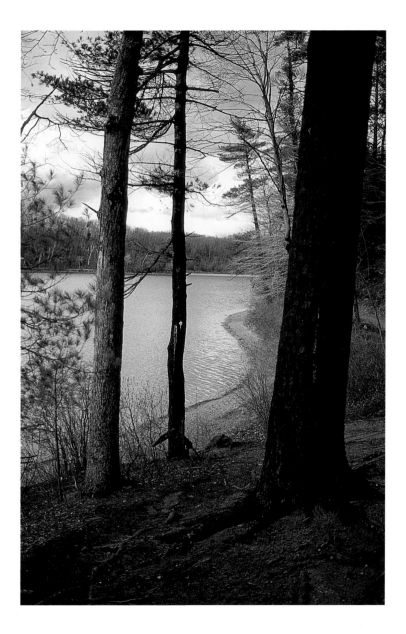

FROM UNDER A ROTTEN STUMP
my hoe turned up a sluggish por-
tentous and outlandish spotted
salamander, a trace of Egypt and
the Nile, yet our contemporary.

ON THE 29TH OF APRIL, AS I WAS FISHING . . .
I heard a singular rattling sound, somewhat like
that of the sticks which boys play with their fin-
gers, when, looking up, I observed a very slight
and graceful hawk, like a nighthawk, alternately
soaring like a ripple and tumbling a rod or two
over and over, showing the underside of its
wings, which gleamed like a satin ribbon in the
sun, or like the pearly inside of a shell. This
sight reminded me of falconry and what noble-
ness and poetry are associated with that sport.
The merlin it seemed to me it might be called:
but I care not for its name. It was the most ethe-
real flight I had ever witnessed.

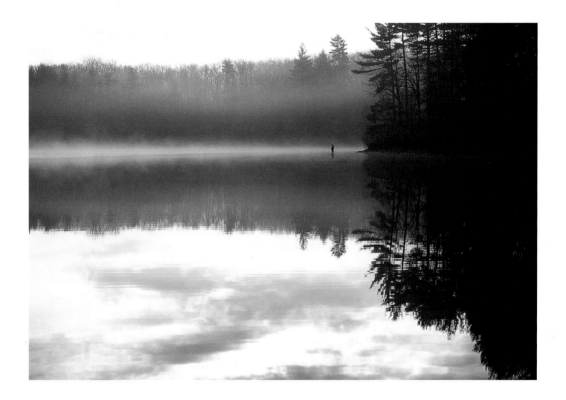

EARLY IN MAY, THE OAKS, HICKORIES, MAPLES,
and other trees, just putting out amidst the pine
woods around the pond, imparted a brightness
like sunshine to the landscape, especially in cloudy
days, as if the sun were breaking through mists
and shining faintly on the hillsides here and there.

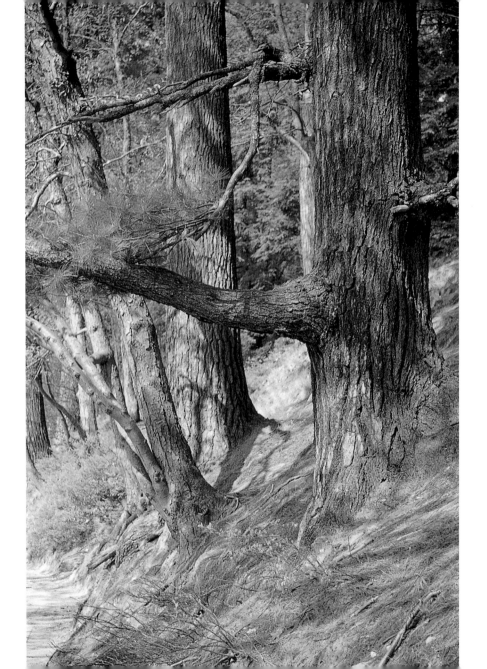

A LAKE IS THE LANDSCAPE'S MOST BEAUTIFUL AND EXPRESSIVE feature. It is earth's eye, looking into which the beholder measures the depth of his own nature.

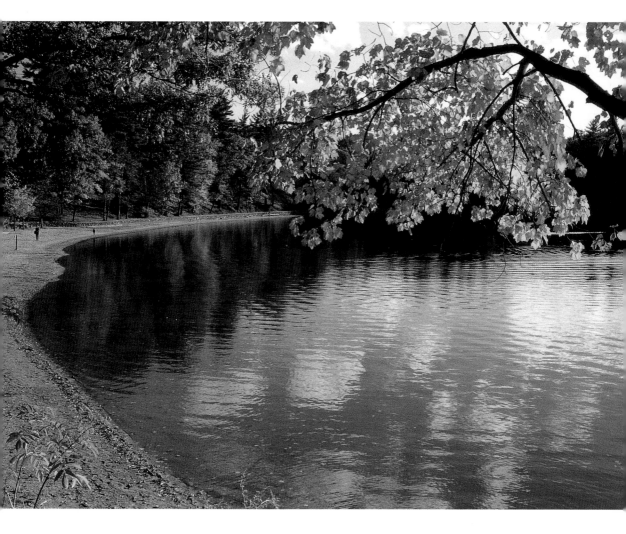

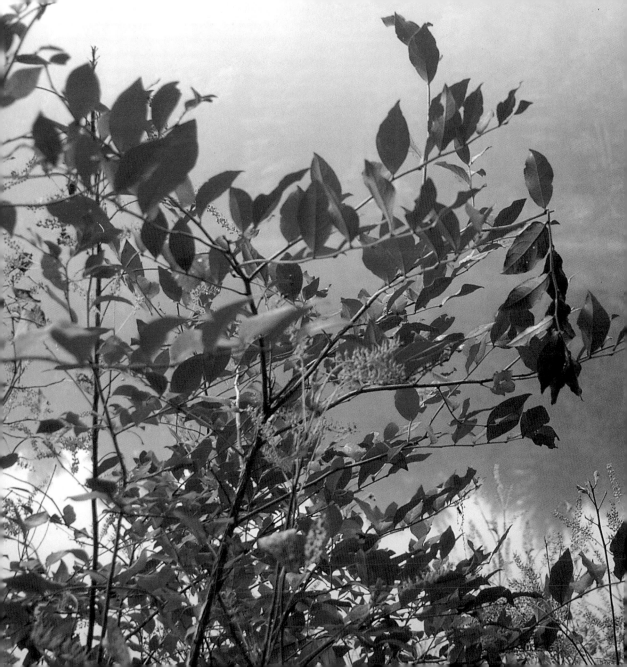

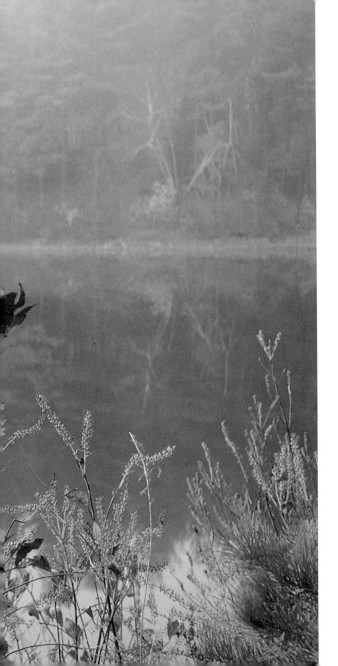

THAT DELICATE, waving, feathery dry grass which I saw yesterday is to be remembered with the autumn. The dry grasses are not dead for me. A beautiful form has as much life at one season as another.

ALREADY, BY THE FIRST OF SEPTEMBER, I HAD SEEN TWO or three small maples turned scarlet across the pond, beneath where the white stems of three aspens diverged, at the point of a promontory, next the water. Ah, many a tale their color told! And gradually from week to week the character of each tree came out, and it admired itself reflected in the smooth mirror of the lake. Each morning the manager of this gallery substituted some new picture, distinguished by more brilliant or harmonious coloring, for the old upon the walls.

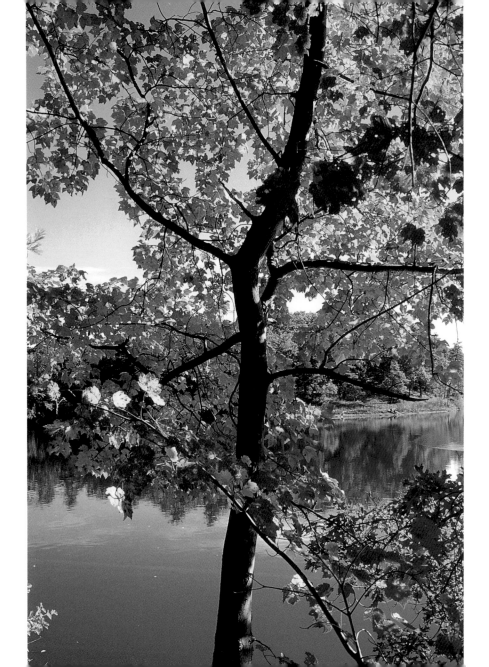

IN SUCH A DAY, IN SEPTEMBER OR OCTOBER, WALDEN is a perfect forest mirror, set round with stones as precious to my eye as if fewer or rarer. Nothing so fair, so pure, and at the same time so large, as a lake, perchance, lies on the surface of the earth. Sky water. It needs no fence. Nations come and go without defiling it. It is a mirror which no stone can crack, whose quicksilver will never wear off, whose gilding Nature continually repairs; no storms, no dust, can dim its surface ever fresh;—a mirror in which all impurity presented to it sinks, swept and dusted by the sun's hazy brush—this the light dust-cloth—which retains no breath that is breathed on it, but sends its own to float as clouds high above its surface, and be reflected in its bosom still.

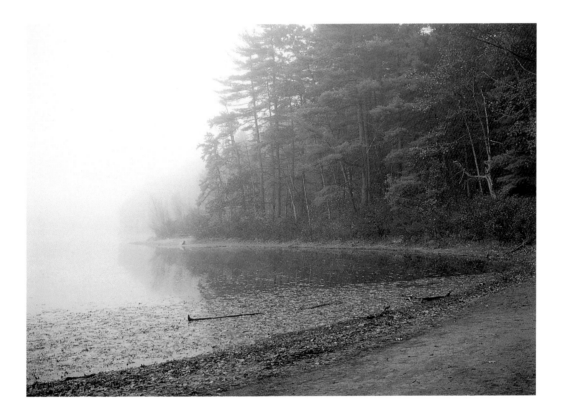

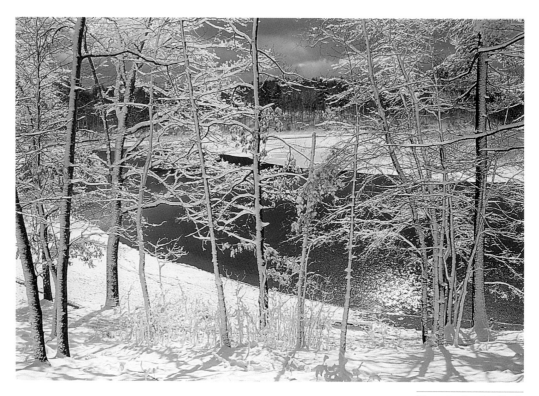

Photo by Jim McGrath

THE SNOW HAD ALREADY COVERED THE GROUND SINCE the 25th of November, and surrounded me suddenly with the scenery of winter. I withdrew yet farther into my shell, and endeavoured to keep a bright fire within my house and within my breast.

WALDEN, BEING LIKE THE REST USUALLY BARE OF SNOW, or with only shallow and interrupted drifts on it, was my yard where I could walk freely when the snow was nearly two feet deep on a level elsewhere and the villagers were confined to their streets. There, far from the village street, and, except at very long intervals, from the jingle of sleigh-bells, I slid and skated, as in a vast moose-yard well trodden, overhung by oak woods and solemn pines bent down with snow or bristling with icicles.

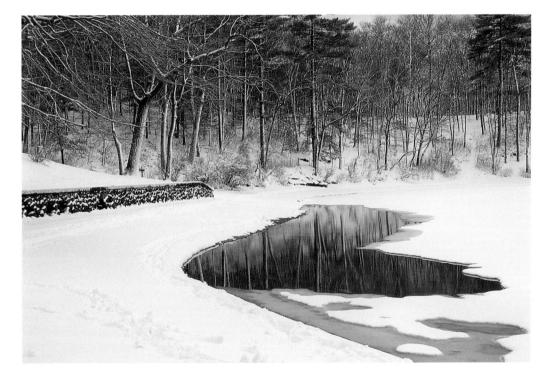

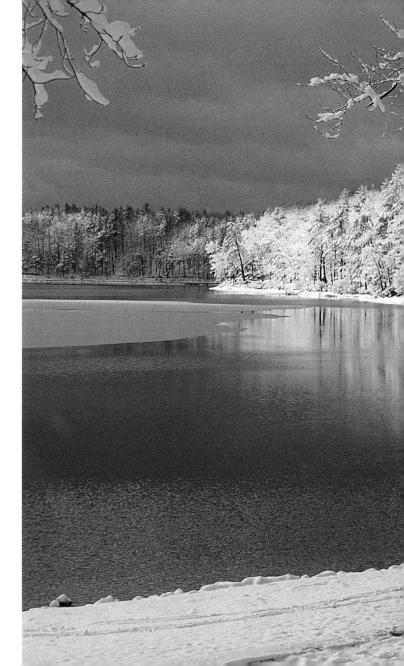

AFTER A STILL WINTER night I awoke with the impression that some question had been put to me, which I had been endeavoring in vain to answer in my sleep, as what—how —when—where? But there was dawning Nature, in whom all creatures live, looking in at my broad windows with serene and satisfied face, and no question on her lips. I awoke to an answered question, to Nature and daylight.

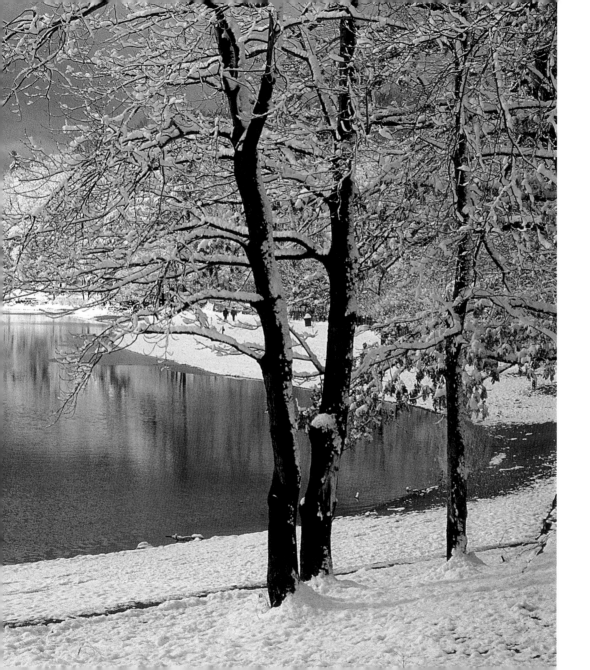

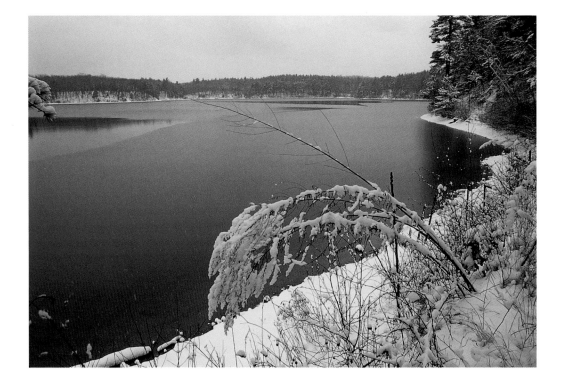

NOT TILL WE ARE LOST—IN OTHER WORDS, NOT TILL WE HAVE lost the world—do we begin to find ourselves, and realise where we are, and the infinite extent of our relations.

THE INDESCRIBABLE INNOCENCE AND BENEFICENCE OF NATURE —of sun, and wind, and rain, of summer and winter—such health, such cheer, they afford for ever! And such sympathy have they ever with our race, that all Nature would be affected, and the sun's brightness fade, and the winds would sigh humanely, and the clouds rain tears, and the woods shed their leaves and put on mourning in midsummer, if any man should ever for a just cause grieve. Shall I not have intelligence with the earth? Am I not partly leaves and vegetable mould myself?

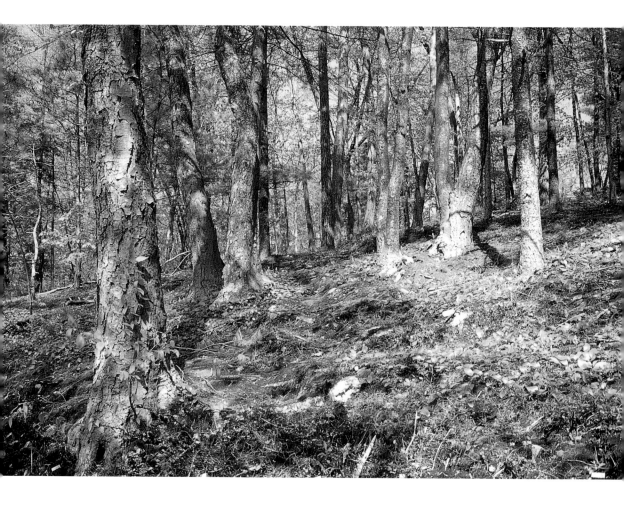

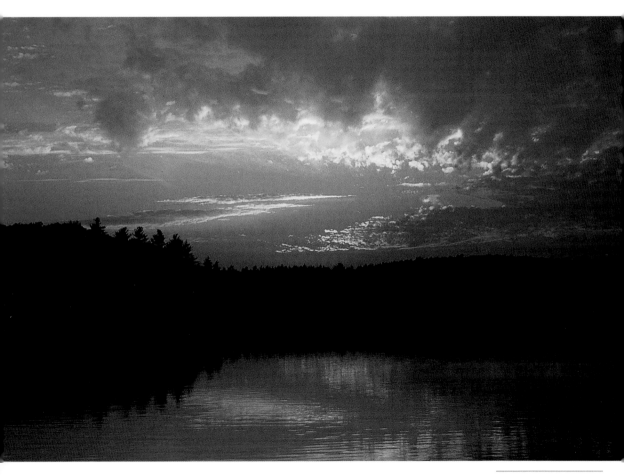

Photo by Jim McGrath

WHEN I WAS FOUR YEARS OLD, AS I WELL REMEMBER,

I was brought from Boston to this my native town,

through these very woods and this field, to the pond.

It is one of the oldest scenes stamped on my memory.

And now to-night my flute has waked the echoes over

that very water. The pines still stand here, older than I.

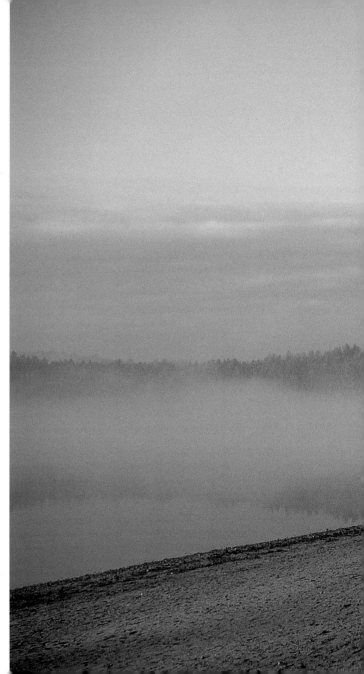

OF ALL THE CHARACTERS
I have known, perhaps,
Walden wears best, and
best preserves its purity.
Many men have been
likened to it, but few
deserve that honour.
Though the wood-chop-
pers have laid bare first
this shore and then that,
. . . and the railroad has
infringed on its border,
and the ice-men have
skimmed it once, it is
itself unchanged, the
same water which my
youthful eyes fell on; all
the change is in me.

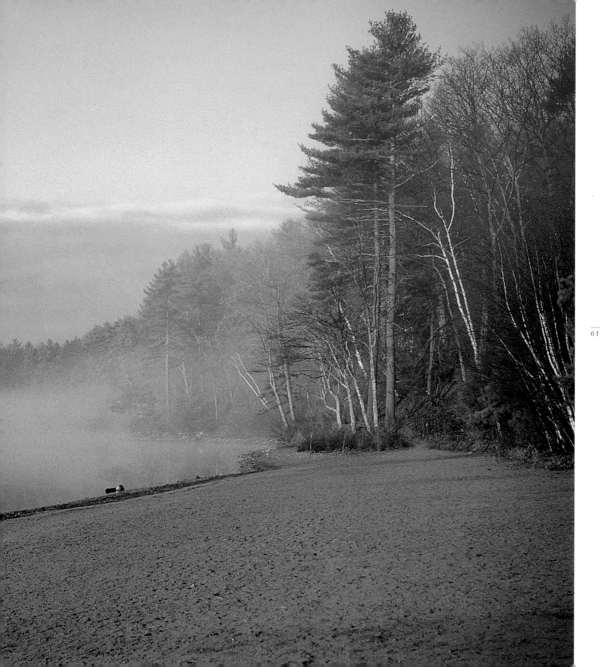

WE MUST LEARN TO REAWAKEN AND KEEP OURSELVES AWAKE, not by mechanical aids, but by an infinite expectation of the dawn, which does not forsake us in our soundest sleep. I know of no more encouraging fact than the unquestionable ability of man to elevate his life by a conscious endeavor. It is something to be able to paint a particular picture, or to carve a statue, and so to make a few objects beautiful; but it is far more glorious to carve and paint the very atmosphere and medium through which we look, which morally we can do. To affect the quality of the day, that is the highest of arts.

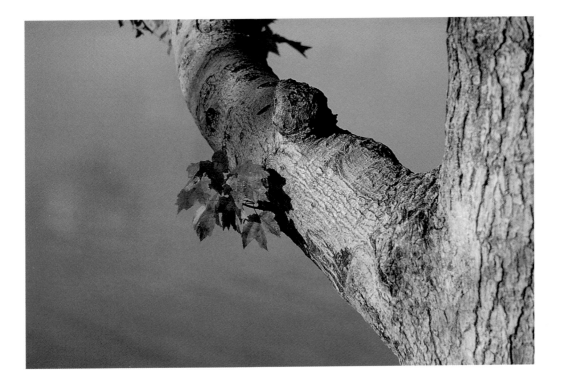

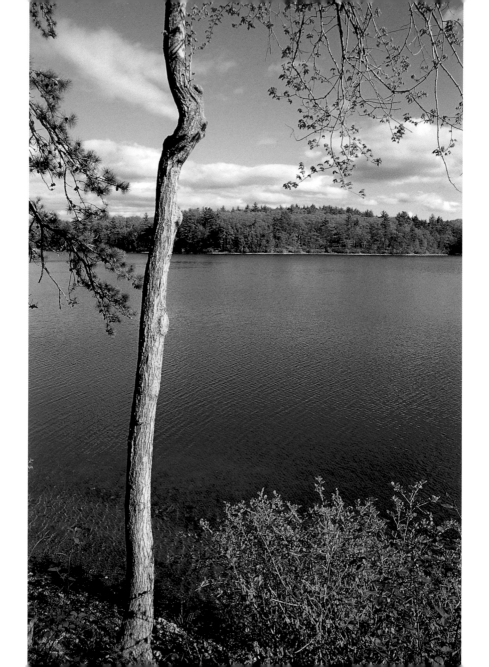

Photo by Jim McGrath

A native of New England, Bonnie McGrath first visited Walden Pond as a child and today walks its shores many times a year. A mother of two and grandmother of three, Bonnie earned her BFA from the Massa-chusetts College of Art. A graphic designer who has long experience in many aspects of book publishing, she exhibits her photos and watercolors throughout eastern New England. Her images have also appeared in many regional and national publications.

Bonnie's photos of Walden are also available as notecards and prints, posters, postcards, and bookmarks. She can be contacted for informa-tion at www.lightdancespirit.com.

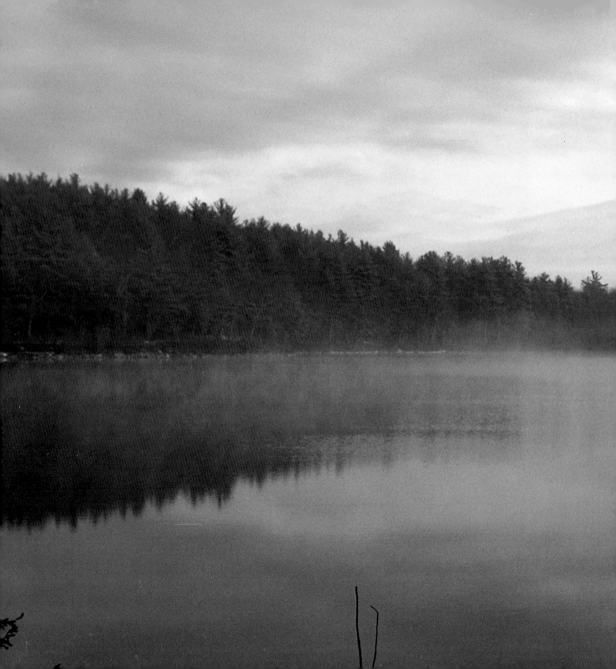